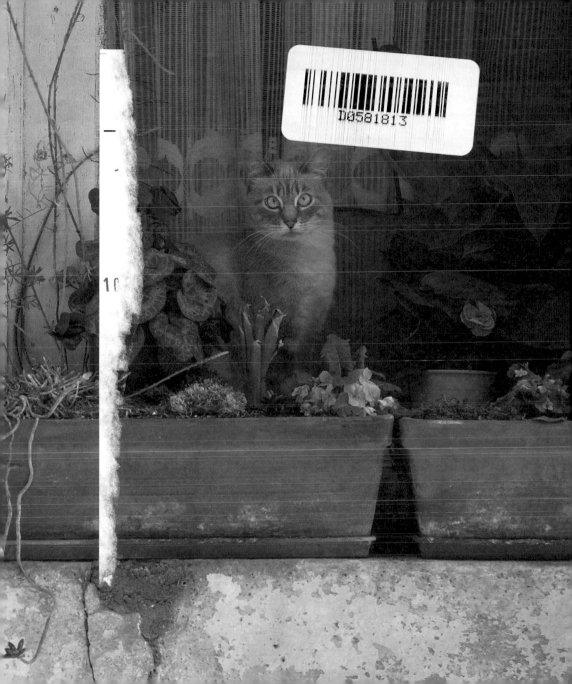

The
FRENCH
CAT

Rachael McKenna

hardie grant books
MELBOURNE · LONDON

in association with PQ Blackwell

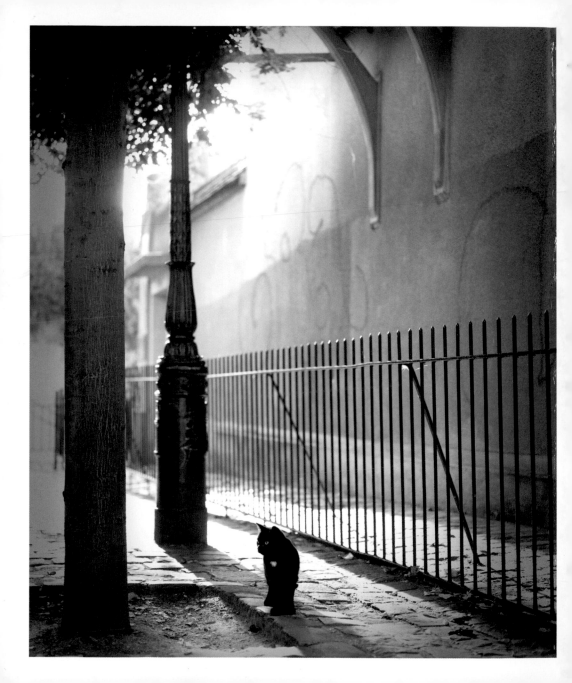

Tous les chats de France

Cats make their own decisions, follow their own instincts and the cats of France are probably the most independent and enigmatic of all. For me, the assignment of photographing French cats was like a love affair. I adored being out on location and capturing cats, showing their true personalities in their own diverse environments.

In the villages of France, you don't see very many overbred pedigree cats. Instead, they are mostly moggies, and, like their owners, are allowed to remain singular, self-contained and standoffish. They appear on rooftops and slinking along window sills and ledges, looking down imperiously at their canine counterparts roaming the streets. Certainly cats love to climb, but these cats make it look as though they choose to lead the high life rather than are compelled to do so.

French city cats have a very different, interior life. In Paris, for example, there are no cats on the streets because their owners are fined if their cats are caught outside. But French cats are clever. Today, hundreds of them hang out in the huge Montmartre Cemetery where they prowl among the graves and sit on the headstones of famous former Parisians.

And what of the cats from some of France's elegant châteaux? Would these privileged pussies be more prince- and princess-like than village cats? Certainly Myrtille (see pages 52–53), the resident cat at Château de Varenne in Provence, was: she obviously considered herself the rightful ruler of the thirty-room French provincial château.

I hope this book goes some way to explain the rhythm of French life, the moody beauty of the countryside, the luminosity of its light, and the unusual, enigmatic character of *le beau chat Français*. Most of all, I hope the images I have created here leave you with a feeling of serenity and calm – which for me is the real essence of life in France.

God made the cat in order that humankind might have the pleasure of caressing the tiger.

———————————

Joseph Méry
(1797–1866, French author, poet and playwright)

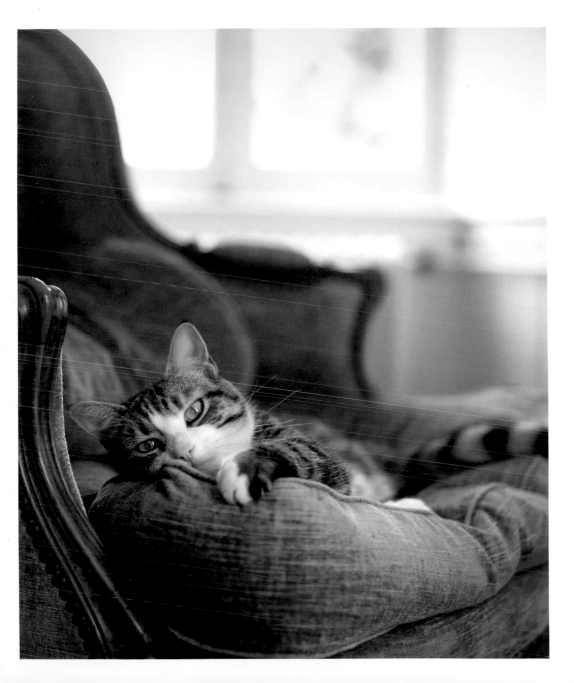

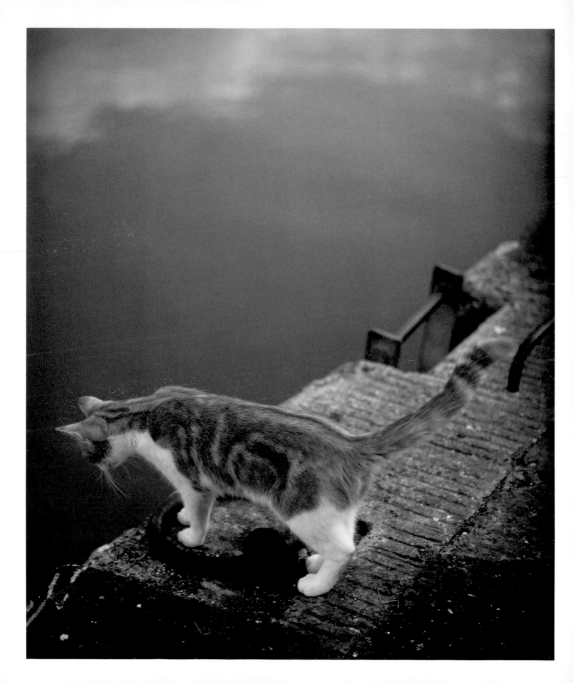

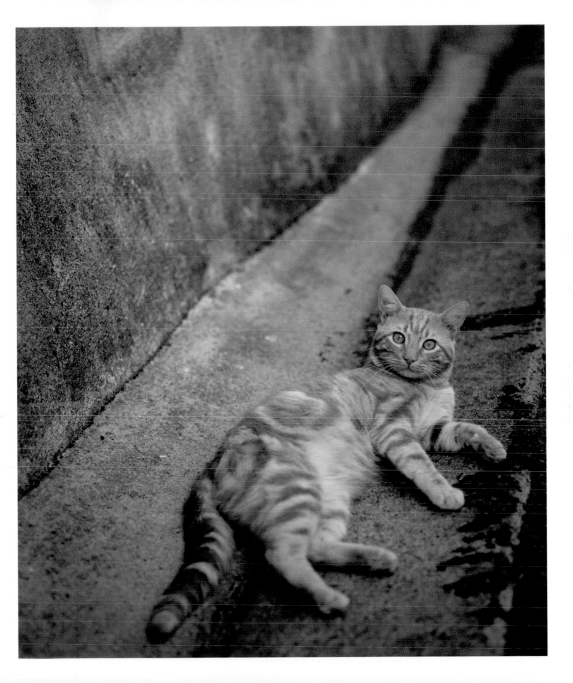

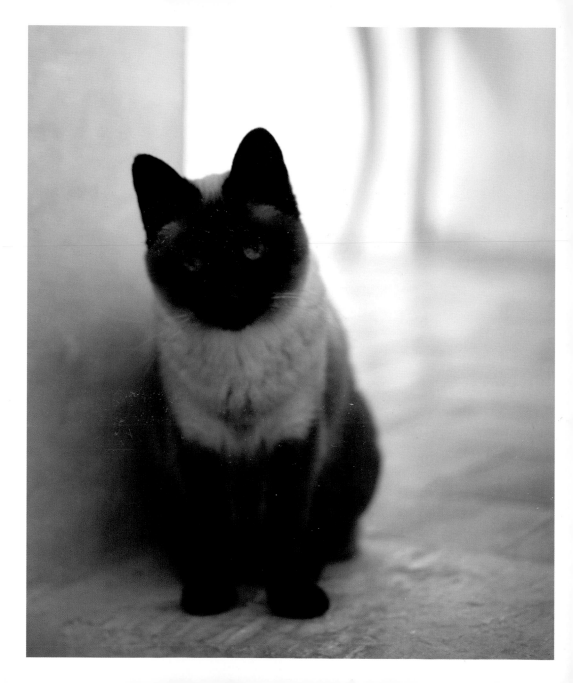

Craquette

Craquette, the much-loved cat at Le Mas de la Rose, delights in resting under the sun lounger on the roof terrace. As I tried to entice her to a more convenient place, she eventually warmed to me and moved from the summer heat to the cool tiles inside. With me sitting on the stairs below, stroking her while she purred in reply, I was able to capture her endearing personality.

Charles Baudelaire (1821–67, French poet and critic)

Baudelaire, a Parisian dandy of the nineteenth-century, was said to enjoy the company of cats more than people. When visiting friends he caused great offence by greeting the household cat first, holding it up, kissing it fondly and not paying the least attention to his hosts. Baudelaire's obsession with the feline is palpable in this extract from his poem, *Le Chat*:

When my fingers leisurely caress you,
Your head and your elastic back,
And when my hand tingles with the pleasure
Of feeling your electric body.

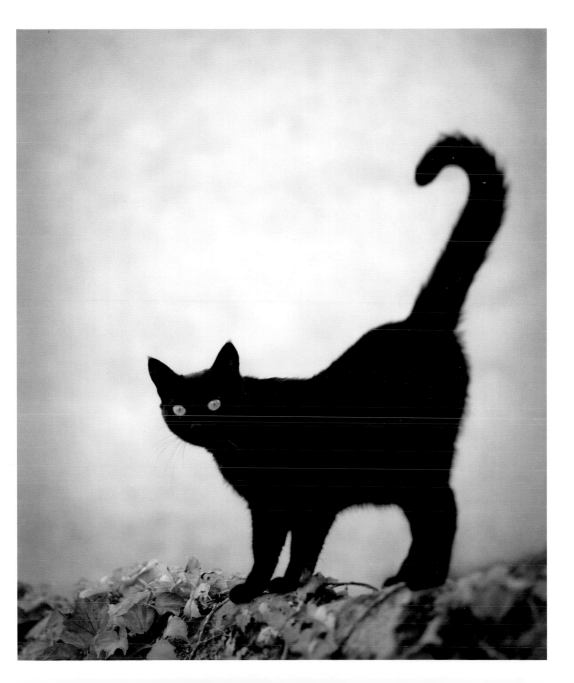

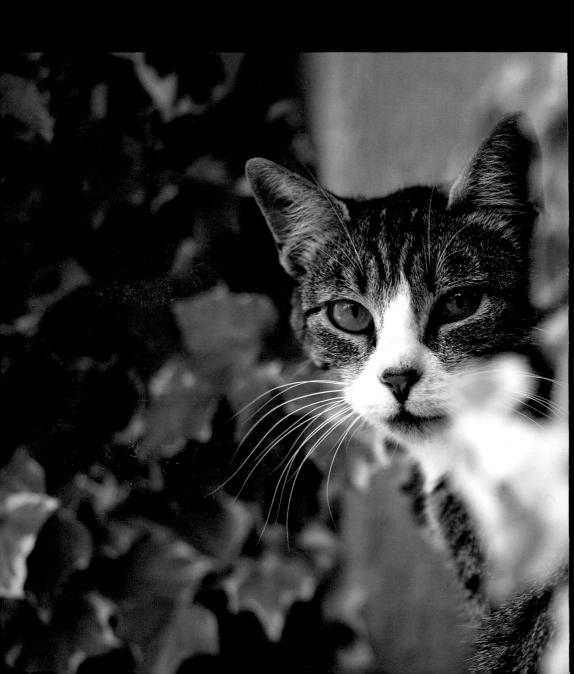

Est-il dieu?

Is he God?

Charles Baudelaire

(1821–67, French poet and critic)

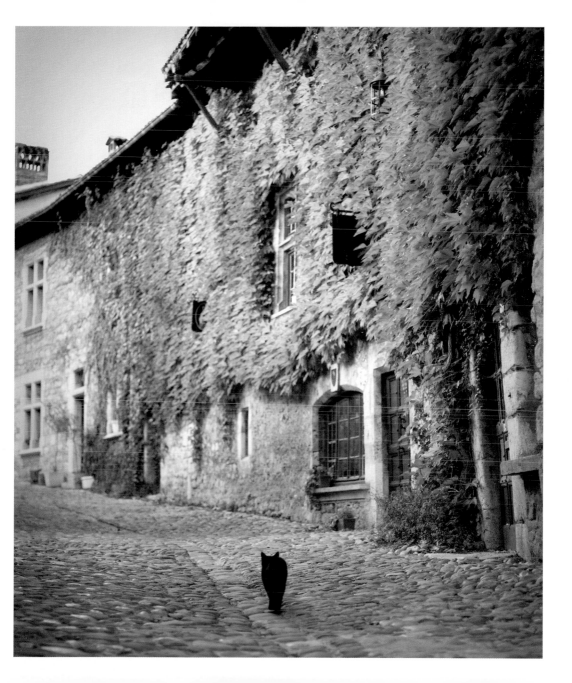

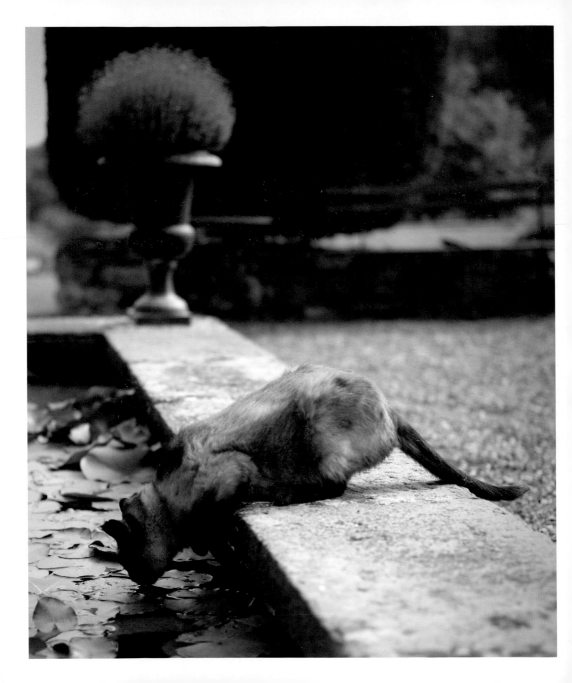

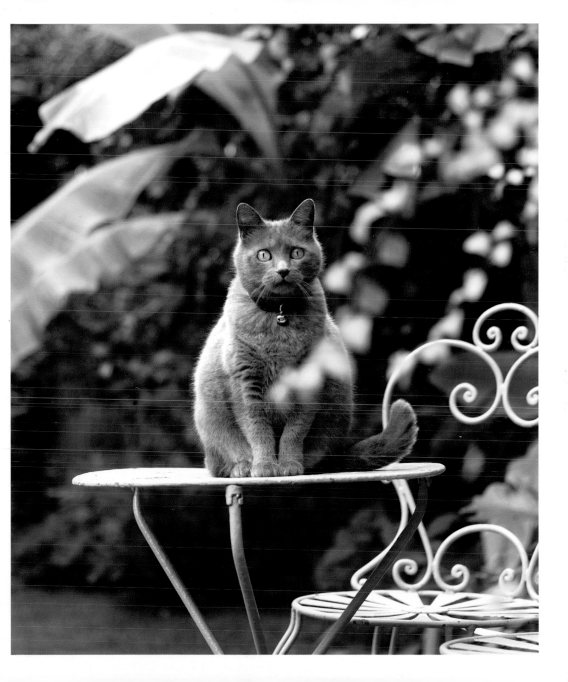

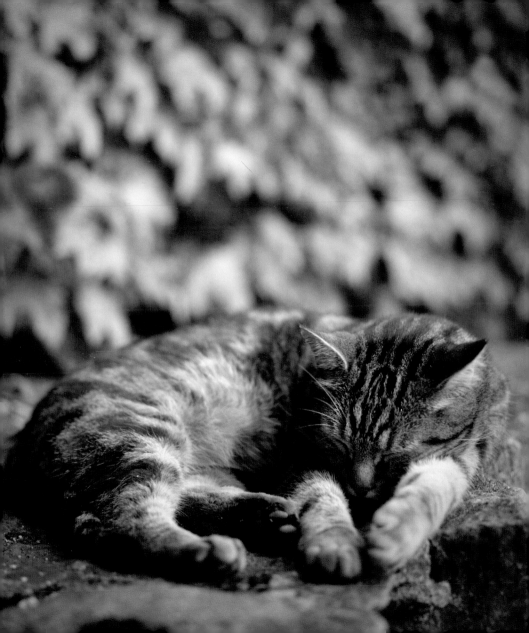

*A little
drowsing cat
is an image
of perfect
beatitude.*

Jules Champfleury
(1820–89, French art critic and novelist)

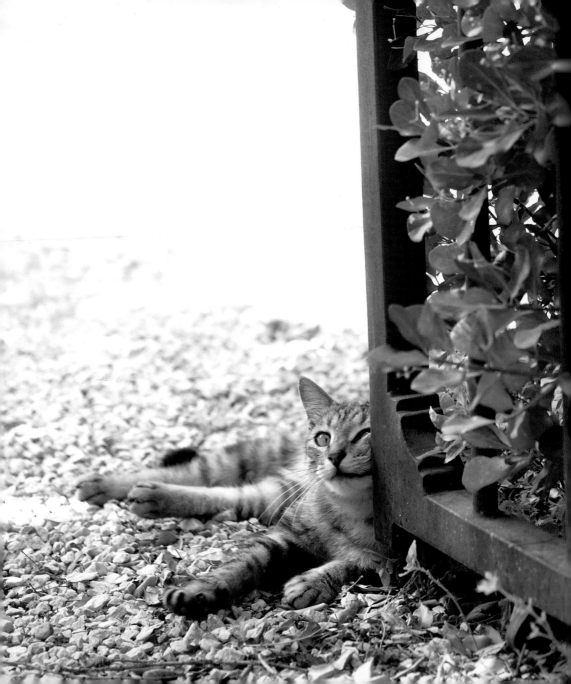

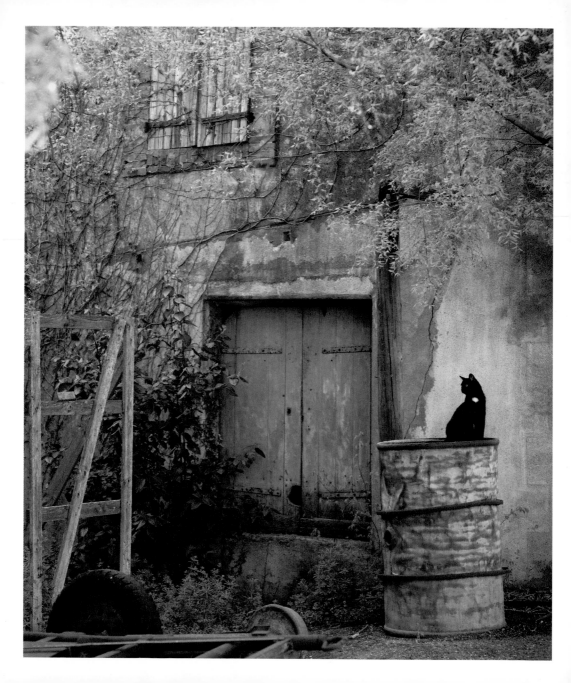

Titus

Every day after walking my dog, I'd pass this building with its crumbling walls, peeling paint and old drum. It was obvious no cats lived nearby, so I asked my neighbour, Karl, if he would bring his cat around the corner for a photo shoot. Titus was brilliant and sat there attentively, while Karl hid behind the drum in case he did a runner.

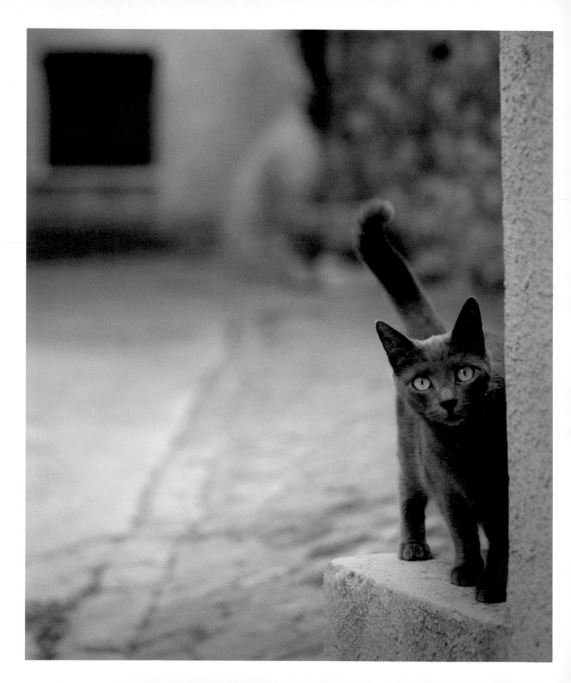

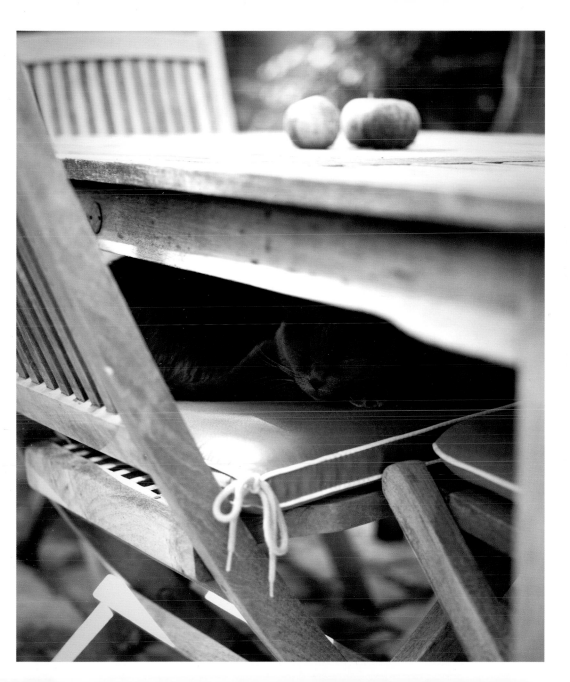

I have studied many philosophers and many cats. The wisdom of cats is infinitely superior.

Hippolyte Adolphe Taine
(1828–93, French critic and historian)

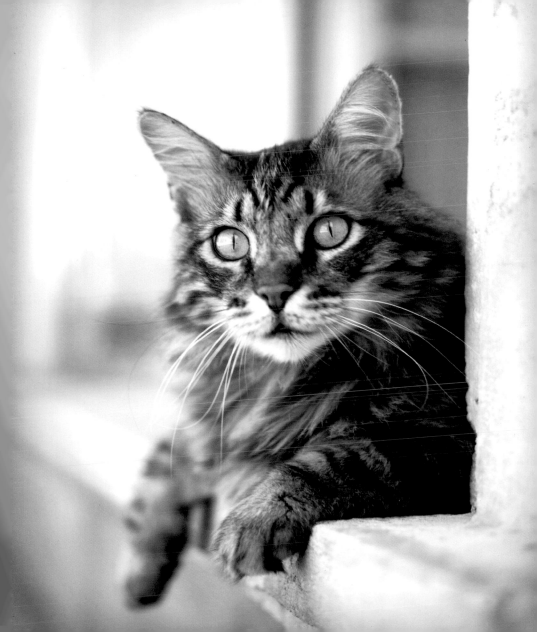

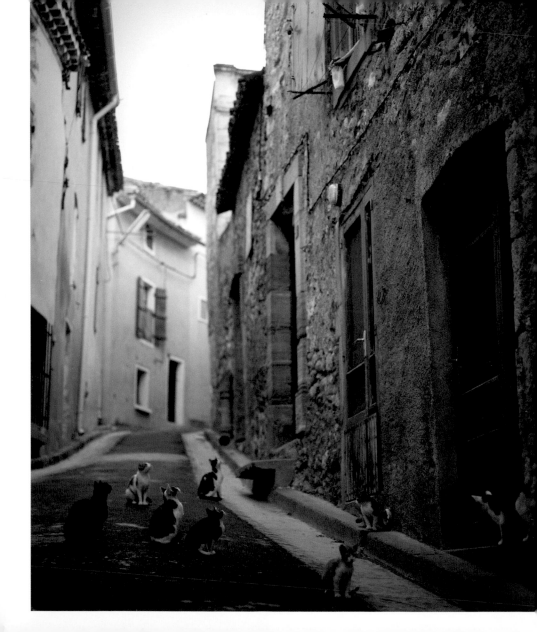

Cardinal Richelieu (1585–1642, French clergyman and prime minister)

Considered to be the world's first prime minister under King Louis XIII, Richelieu was an ardent cat lover. He created a cattery at the Louvre Palace to house dozens of cats and made sure they were taken care of, even after his death.

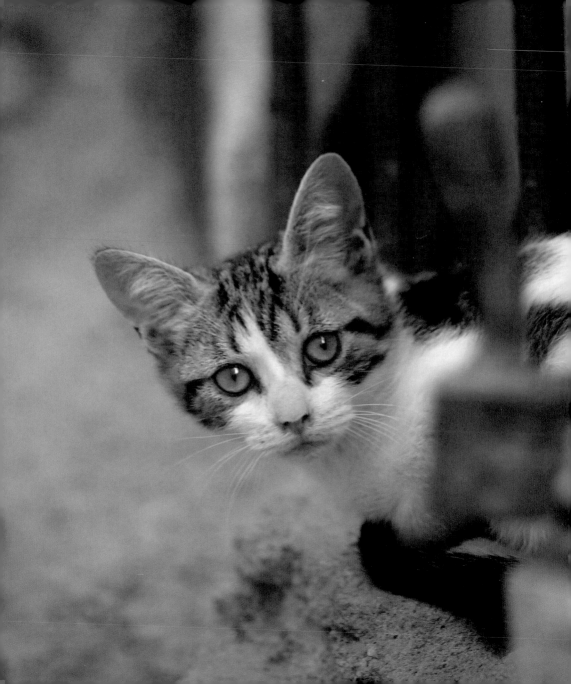

Green eyes inspire grand passions only and nature, which has refused them to the beauties of this century, has lavished them on the cat species.

———————

François-Augustin Paradis de Moncrif
(1687–1770, French writer)

Maurice Ravel (1875-1937, French classical composer)

Ravel loved cats and kept several Siamese at his house Le Belvédère, near Paris. In 1925, he completed the opera *L'enfant et les sortilèges* (The Child and the Enchantments) in collaboration with Sidonie-Gabrielle Colette, who wrote the libretto. The opera features "Duo miaulé", a duet by the tomcat and female cat in their own wordless feline language.

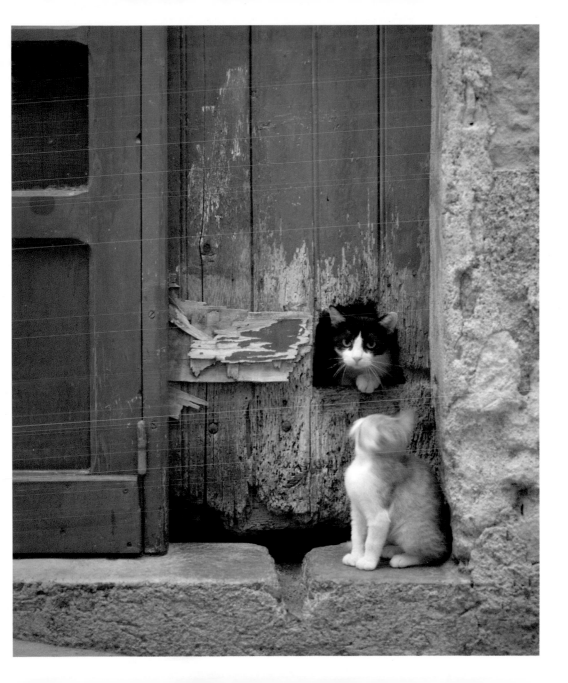

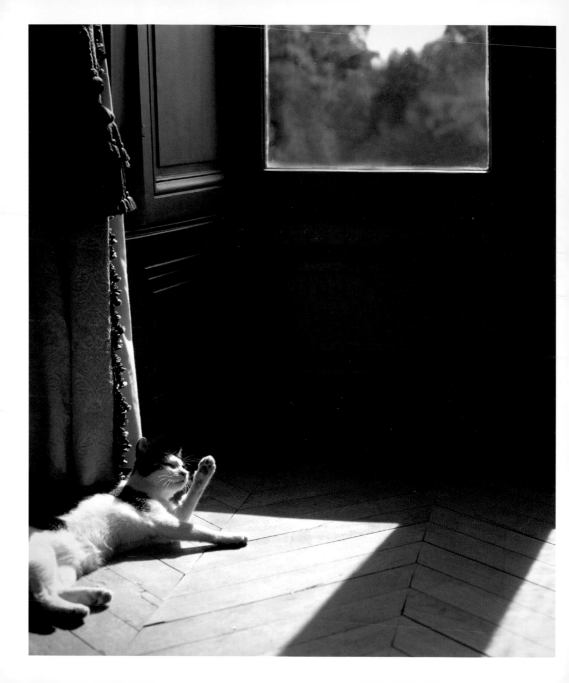

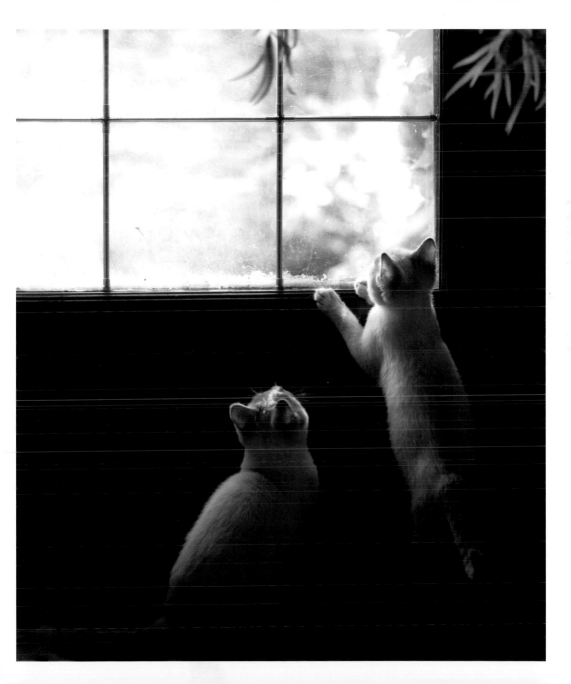

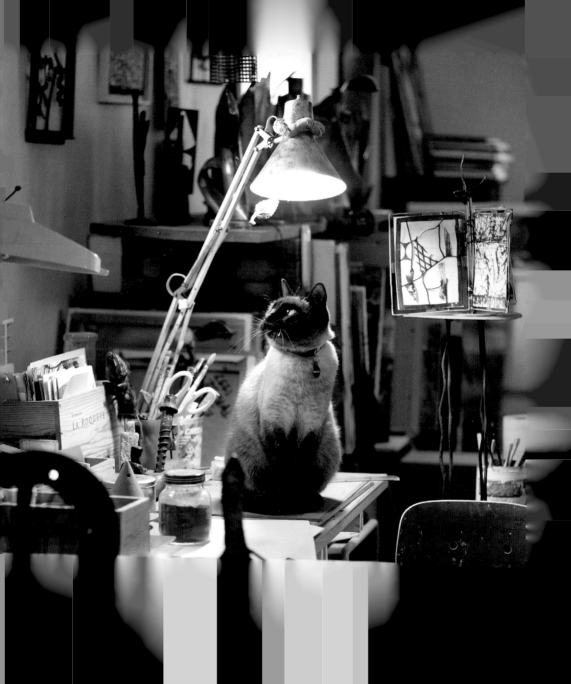

They stray about the house with velvety tread, like the genius loci; or sit beside the writer's table companioning his thought, gazing at him from the depths of their golden eyes, with intelligent tenderness and intuitive penetration ...

Théophile Gautier

(1811–72, French poet, novelist, journalist and critic)

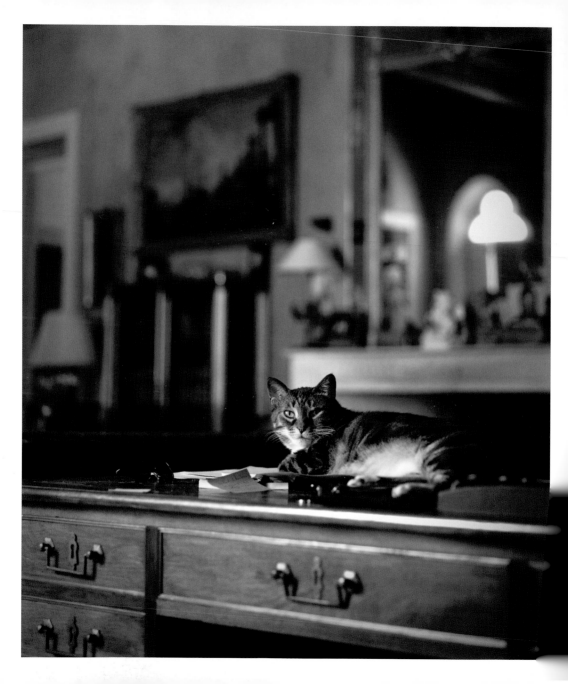

Miss France

When I heard about Miss France of Château de Beauregard, I immediately visualised a petite, shy cat resting on top of an antique desk in a dark room with filtered light... Miss France turned out to be not so petite but she was indeed shy. With the help of her owner, I managed to capture her on her favourite antique desk in this exceptionally beautiful room.

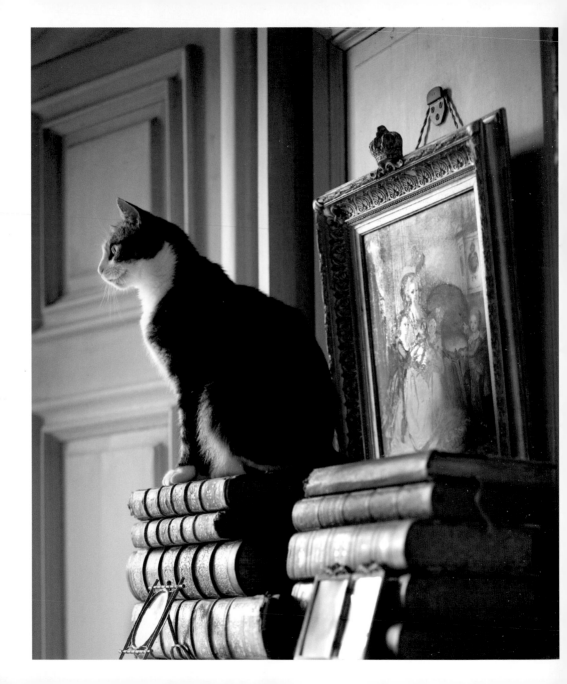

In my house I want:
A reasonable woman,
A cat passing among the books,
And friends in every season
Whom I cannot live without.

—————————————————

Guillaume Apollinaire
(1880–1918, French-Italian-Polish poet)
From *Le Bestiaire, ou Cortège d'Orphée*, 1911

Antoinette Deshoulières (1638–94, French poet)

Antoinette Deshoulières, an acclaimed poet at the court of Louis XIV, conducted a lively correspondence in the name of her cat, Grisette. The pampered feline exchanged many letters with Cochon, the Duc of Vivonne's dog and such was the relationship between the cat and dog that Deshoulières wrote a play about their passion.

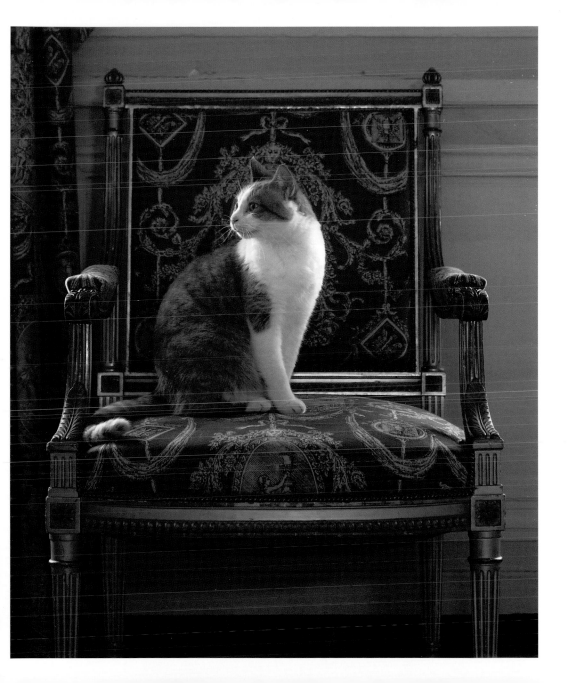

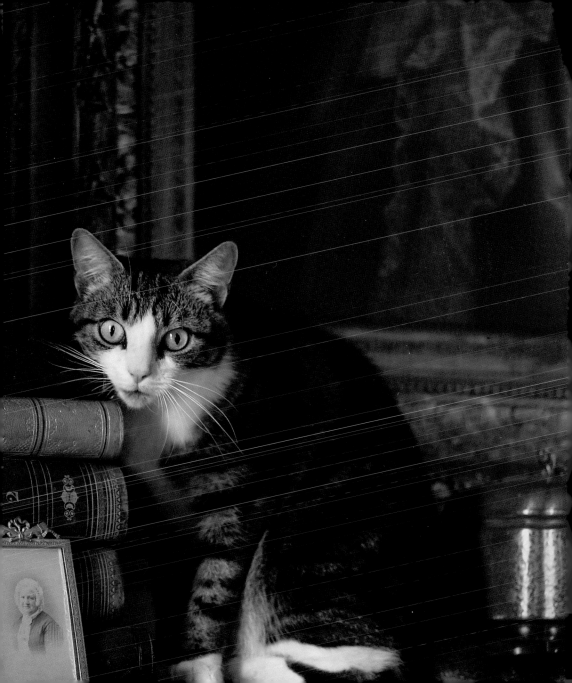

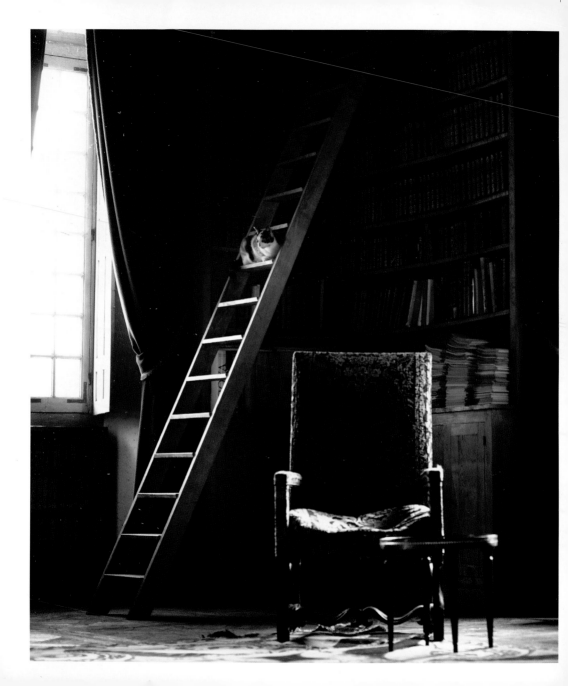

Caramel

It seemed almost surreal to be photographing Caramel scampering around in the library of this virtually untouched seventeenth-century château. She was oblivious to the pulls her claws were making in the fabric of a possibly priceless chair, and I couldn't help but wonder about the characters who had sat in the chair, contributing to the permanent indentations in it.

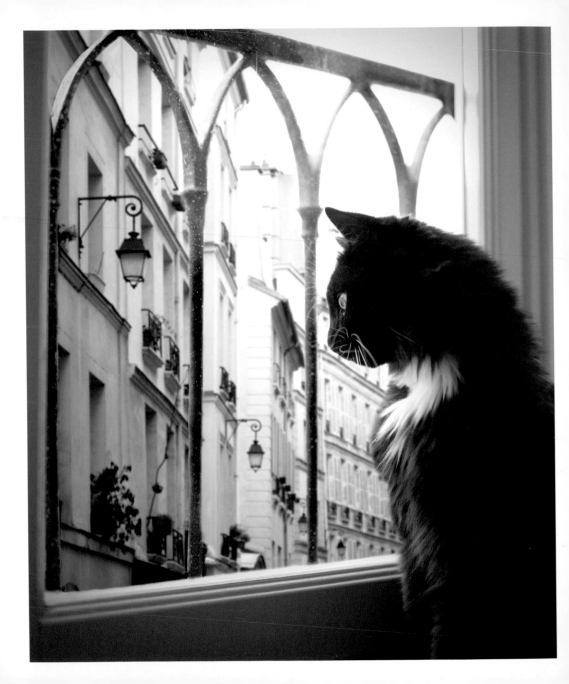

The cat
is a dilettante
in fur.

Théophile Gautier

(1811–72, French poet, novelist, journalist and critic)

Louis XV (1710–74, king of France)

Louis XV had a favourite white Persian Angora. It came to his bedroom every morning and was allowed to play on the table during Councils of State.

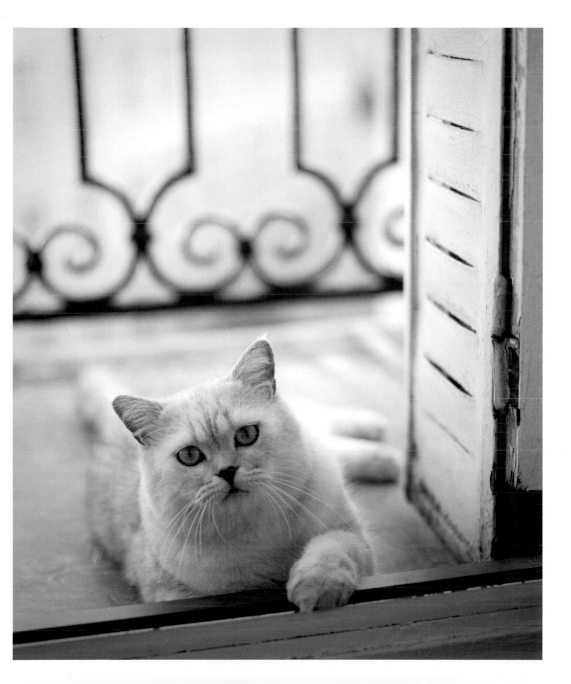

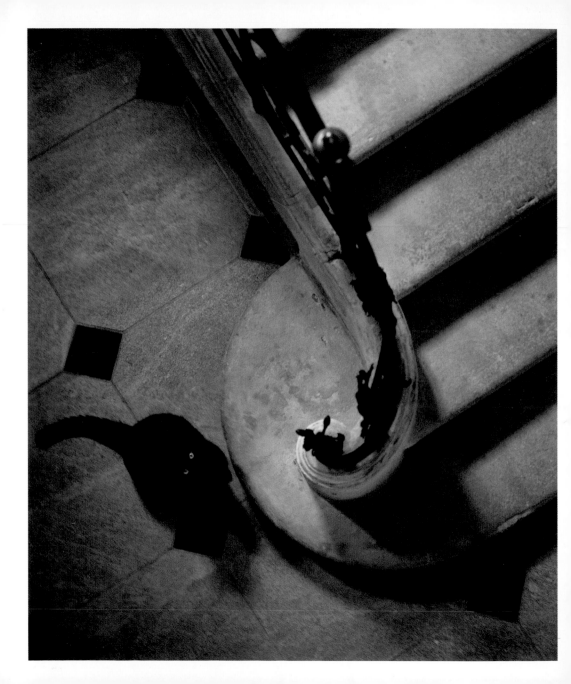

Myrtille

I had been warned that Myrtille had attitude, but completely forgot about it as I watched her move from spot to spot to avoid guests at the château. But when I decided to pick her up for a photograph, she wasn't so accommodating, grabbing my arm with all paws and sinking in her teeth. Of course, as soon as she was back in her spot at the foot of the stairs, Myrtille was happy to oblige – with just a glance to the camera above.

Henri Matisse (1869–1954, French artist)

Matisse's cats, Minouche and Coussi, lived in his Villa le Rêve in Vence. It is said that Minouche had an "M" for Matisse on his forehead. The cats kept the artist company, especially when he was confined to bed due to poor health.

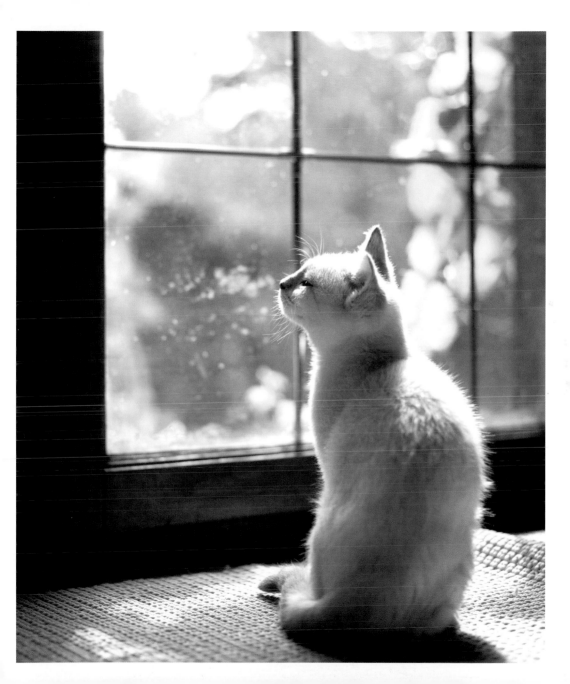

The cat is a drawing-room tiger.

Victor Hugo

(1802–85, French poet, novelist, playwright and statesman)

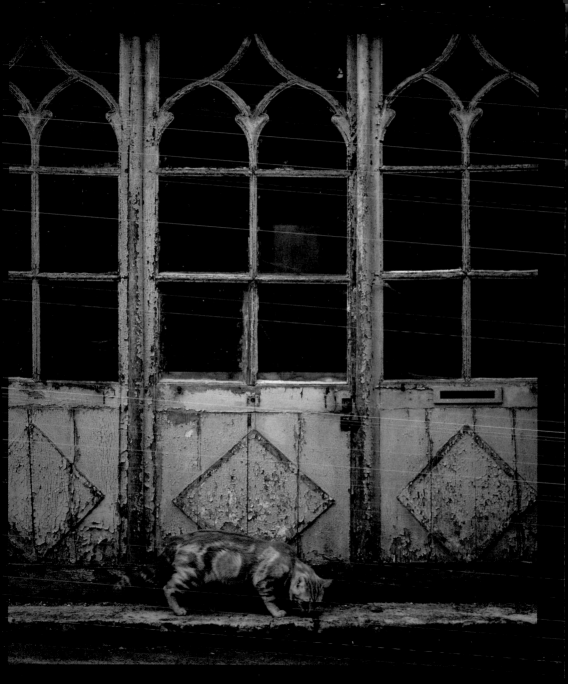

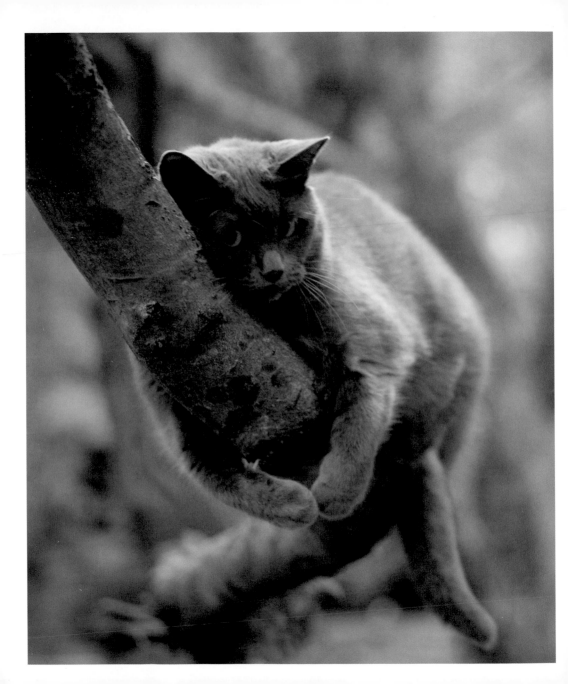

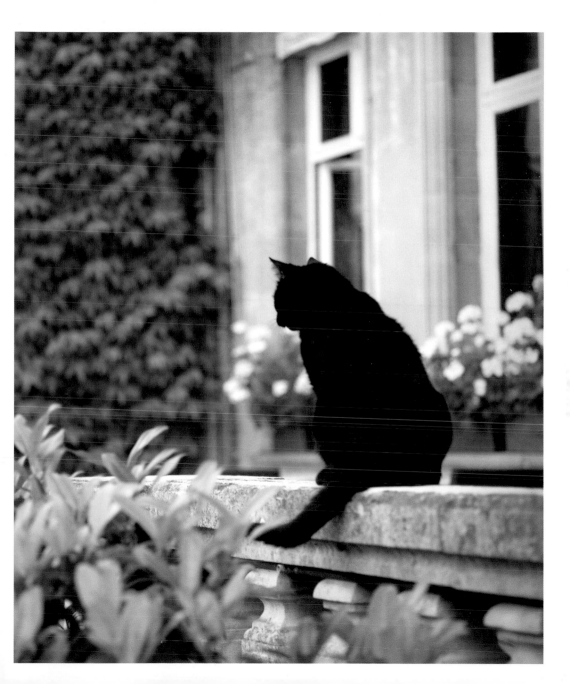

I believe cats to be spirits come to earth. A cat, I am sure, could walk on a cloud without coming through.

Jules Verne
(1828–1905, French author)

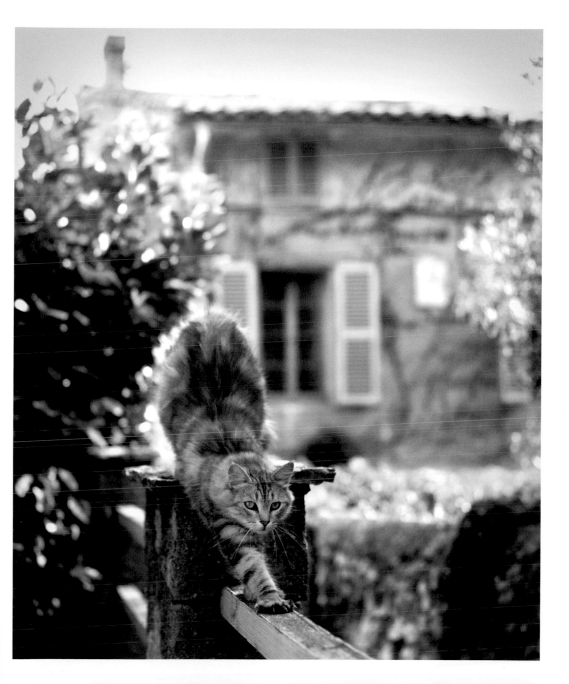

I love cats because I enjoy my home;
and little by little, they become its visible soul.

Jean Cocteau

(1889–1963, French poet, novelist, playwright and filmmaker)

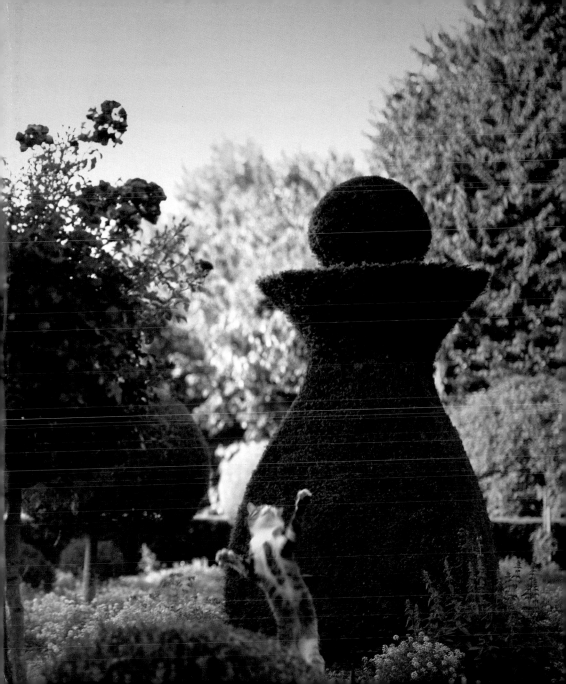

Images (by page)

ISBN 978-174270582-8

Produced and originated by PQ Blackwell Limited
116 Symonds Street, Auckland 1010, New Zealand
www.pqblackwell.com

Text: Rachael Hale-McKenna and Carroll du Chateau
Book design: Helene Dehmer
Editorial: Lisette du Plessis and Rachel Clare

Published in 2013 by Hardie Grant Books

Hardie Grant Books (Australia)
Ground Floor, Building 1
658 Church Street
Richmond, Victoria 3121
www.hardiegrant.com.au

Hardie Grant Books (UK)
Dudley House, North Suite
34–35 Southampton Street
London WC2E 7HF
www.hardiegrant.co.uk

Printed by 1010 Printing International Limited, China

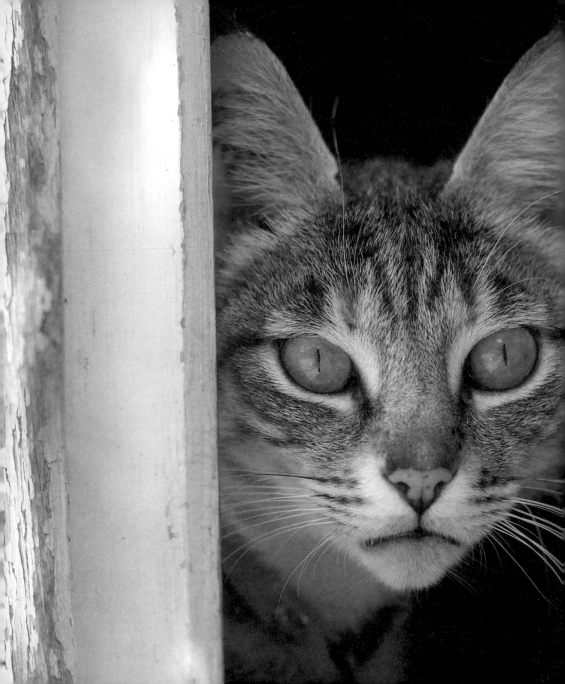